art-to-go

A TRAVELER'S

GUIDE TO

PAINTING

IN OILS

First published in the United States of America by:
Quarry Books, an imprint of Rockport Publishers, Inc.
146 Granite Street
Rockport, Massachusetts 01966-1299
Telephone: (508) 546-9590
Fax: (508) 546-7141

Distributed to the book trade and art trade in the United States by:
North Light, an imprint of
F & W Publications
1507 Dana Avenue
Cincinnati, Ohio 45207
Telephone: (800) 289-0963

Other Distribution by:
Rockport Publishers
Rockport, Massachusetts 01966-1299

ISBN 1-56496-250-4

10 9 8 7 6 5 4 3 2 1

Design: Sawyer Design Associates, Inc.
Cover postcards from top: *Stonington, Maine*
 Alfred C. Chadbourne;
 Page 50;
 Page 65

Printed in Hong Kong by Excel Printing Company

ART
-to-
GO

A TRAVELER'S GUIDE TO

Painting in Oils

LYNN LEON LOSCUTOFF

QUARRY BOOKS
ROCKPORT, MASSACHUSETTS

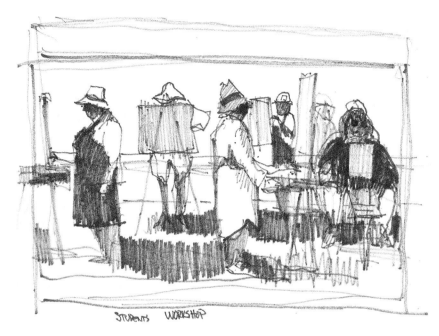

Students' Workshop, *Alfred C. Chadbourn*

 # ACKNOWLEDGMENTS

I wish to thank my family—Carol and Stephen Hoyt, Holly Randall, little Jim and Debby Loscutoff—for their patience and loving support; and my husband, Jim, of course, for saying yes to my spending a summer painting in Normandy and for understanding my need to be creative. Thanks, also, to Lynn St. Claire for her advice; and to my sisters, Alice Brandt and Agnes Newdoll, for spending a lot of time hanging around museums with me.

To all of the artists who have contributed to this book, I am truly grateful.

There is a chemistry among artists; respect, love, commitment, and incredible sharing. I have once again experienced this joyous feeling. The response to my request for materials for this book has been gratifying. I sincerely thank the contributing artists. This seems like a small book, however it symbolizes a very large effort on the part of all of us to: share with other artists the continuous adventure of solving problems and learning to make decisions; come up with workable solutions; and carry on the spirit of recording new and challenging painting opportunities. I gratefully acknowledge the talent and giving attitudes of my fellow artists: Jason Berger, Thomas S. Buechner, Alfred C. Chadbourn, NA, Ann Fisk, Diana Horowitz, John Nesta, Simon Marsh, Roger Martin, Harold Rotenberg, Charles Sovek, Don Stone NA, AWS, DF.

Special thanks to: Stan Patey, Rosalie Grattaroti, Shawna Mullen, and the staff at Rockport Publishers for their assistance and support; to Lucy Kohler for her patient help; and to Ed Leon for being there.

—*Lynn Leon Loscutoff*

Where the Sky Meets Me,
Lynn Leon Loscutoff
Painted on site in New
Mexico.

CONTENTS

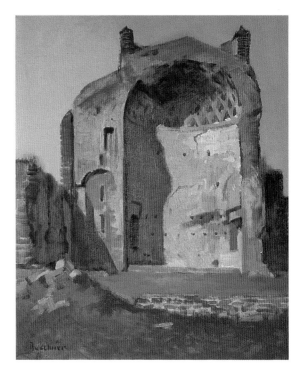

Rome, *Thomas S. Buechner*

INTRODUCTION

*A*s an artist, I feel that the landscape is Mother Earth's garden. Painting *en plein air* in order to capture the earth's essence makes me feel closer to the cycles of life. Whether you are an experienced studio painter or simply a person who has decided your time to paint and travel has come, I invite you to pick up your brushes and join me for a journey of painting adventures.

Traveling and painting with oil paint is a particularly tantalizing challenge. For those with a passion for the richness, sensuous consistency, and satisfying magic of the medium, traveling and painting with oils offers a harvest of pleasure.

In the pages that follow, an accomplished group of artists who love to travel and paint will share with you their diverse ways of using the oil medium, their favorite modes of travel, and their suggestions for packing supplies. Whatever your pleasure—whether it is a day of walking in the local woods with your backpack and pochade box, or a month flying off on a wild escape to a long-dreamed-of holiday of painting abroad—happy solutions await you.

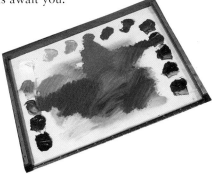

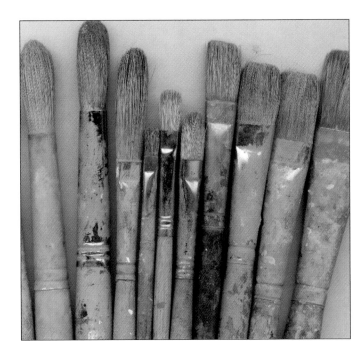

*P*lanning, anticipation, and excitement are all part of the joy of creating art. For the traveling artist, planning is especially key. Having the right supplies can save precious painting time, so throughout this chapter you will find suggestions for what to leave at home, what to take, and how to get it all into your suitcase. Before you set out, whether for a day trip or a trip to Paris, consult the checklist at the end of this chapter.

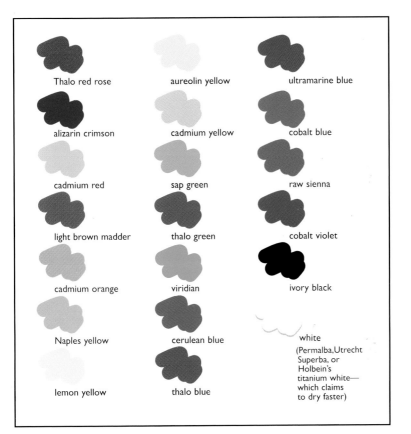

Thalo red rose

aureolin yellow

ultramarine blue

alizarin crimson

cadmium yellow

cobalt blue

cadmium red

sap green

raw sienna

light brown madder

thalo green

cobalt violet

cadmium orange

viridian

ivory black

Naples yellow

cerulean blue

white
(Permalba, Utrecht
Superba, or
Holbein's
titanium white—
which claims
to dry faster)

lemon yellow

thalo blue

A basic palette for the traveling painter.

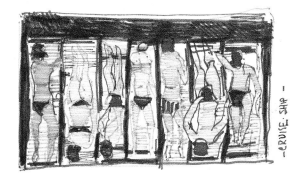

Cruise Ship,
Alfred C. Chadbourn

*T*raveling with oil paints need not be intimidating, oils are a more versatile and flexible medium than most people realize. What you select may change according to each trip. Many of these oil-painting options can be used together or separately:

- traditional tube paints
- Alkyds (fast-drying resin paints*)
- Max oil color (cleans up with soap and water; no solvents needed)
- oil bars, sticks, or crayons

Whatever combination you choose, you need not bring along your whole studio to have a good selection of colors. Many of the great masters worked with a limited palette, and a lot depends on where you are going. (I like to take along wild magentas and vivid colors when I go to tropical climates.) The palette on page 11 fits in a small suitcase, but accommodates ambitious painting ideas.

* Revolutionary new alkyd paints are available in both water- and solvent-soluble versions. See Resources.

Have on hand at least a dozen brushes, sizes one through twelve. I prefer Robert Simmons or Grumbacher. I like to take some filbert-bristle brushes (Numbers Four, Six, and Eight), a Number Eight sable for softening edges, and a Number Two and Three rigger. I am in love with line, so I also like certain fine-point brushes, such as Yarka's Number Two sable. (Yarka imports sables at affordable prices.) For clean mixing, remember to take a palette knife, too.

Depending on the type of trip, I travel with any-where from one to three "art bags." Each is designed for portability, and each nests comfortably inside the next larger size. The oil painter's travel companion, or bag #1, can be any small zippered bag (4" × 6" / 10 cm × 15 cm-size works well) filled with essential supplies for sketching. I often add bag #1 to a larger canvas or nylon bag, which I call oil paint à la carte, or bag #2. This bag should have handles and a shoulder strap, to make carrying blocks of paper and additional supplies easier. Finally, my favorite bag for traveling very long distances is the oil painter's road trip bag, or bag #3, which contains bags number 1 and 2 and then some. No matter where you are traveling, do not check your art supply bags when you board the plane. Carry them with you. You can always replace lost luggage containing underwear, but art supplies, especially overseas, are precious.

Quick-Dry Tip

One trick for fast-drying oil paints is to add Cobalt drier to your medium, then lay paintings face-up on newspaper or a piece of plastic. They should dry overnight.

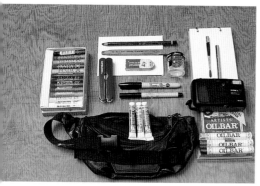

The oil painter's travel
companion, *bag #1*

Bag #1 enables you to sketch any-where. Whether you are on a short trip or a long stay, this bag should accompany you. Keep it in your glove compartment or carry it in a fanny pack, briefcase, or purse.

Contents should include:

- oil sticks, Max, AquaOil, or any other oil paint that cleans up with water
- sketchbook with rigid back
- camera (Polaroid, or small automatic with flash)
- pencils: soft black lead (3B or 4B) or a flat carpenter's pencil (colored pencils optional)
- pencil sharpener and kneaded eraser
- permanent ink pens
- folding brush
- small piece of disposable palette paper (I carry it in an empty 2" × 4" / 5 cm × 10 cm plastic video camera-film container)
- small jar or empty plastic film container for water
- optional: a tiny canvas board (3" × 5" / 7.5 cm × 12.5 cm)
- tissue (not shown)

Bag #2 is a medium-size bag with enough supplies for walking trips or making small paintings. A standard backpack or a waterproof canvas bag with handles are convenient sizes for this bag. In addition to bag #1, bag #2 holds a half-size French easel or a small Yarka Russian easel, plus a small Easel Pal or pochade box.

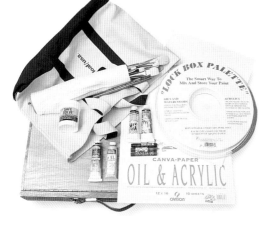

The oil painter's road trip bag, bag #3, pictured with Artist's Backpack from Jack Richeson (see Resources). This bag can hold a full-size easel, art bags 1 and 2, and assorted extras. Removable padded shoulder straps and a handle let you use it as a backpack or carry it.

Pack some canvas—sizes 8" × 10" (20.5 cm × 25.5 cm), 11" × 14" (28 cm × 35.5 cm), 12" × 16" (30 cm × 41 cm), or 14"× 16" (35 cm × 40 cm)—and some gessoed masonite or canvas boards, as well. You may want to include extra paints, brushes, solvents, a Double-Dipper solvent tin, spray fixative (if you use charcoal on your painting surface), and paper towels. Always bring a covered jar or can to hold used solvents and paint cloths. Protect the environment; don't throw paint cloths or combustible solvents in trash cans.

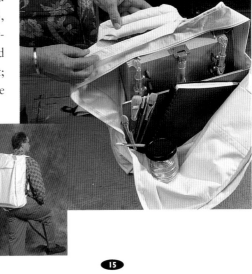

A Garden of Easels

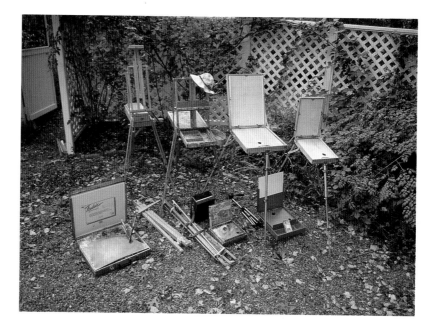

*A*s I talked with artists about their favorite easels, a strange, warm look would come into their eyes. Artists often have "easel fetishes," and it is easy to see why. There is a size, country of origin, style, and weight of easel for every mood and mode of travel. Some old favorites are pictured above: (standing, left to right) The two folding, wooden French easels are great for painters traveling by car or walking with a luggage cart. For extended stays, combine one with Jack Richeson's Artist's Backpack. The Yarka, a Russian easel, comes in two sizes: 16" × 21" (40.5 cm × 53.5 cm), 12 lbs. and 11" x 16" (28 cm × 40.5 cm), 7 lbs.

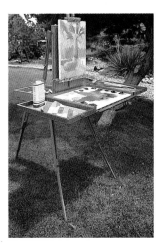

An open paint box can become an inexpensive, portable easel with the addition of a simple strap. Attach the strap around your waist and balance the box on your lap while you paint. Opposite left, lying flat but ready to assemble, are two folding easels that give versatile support for larger canvases. These field easels, now called Take-It-Easels, were formerly known as Anderson or Gloucester easels. They come with an elongated canvas bag and a shoulder strap for portability, and have an extra leg for stability on uneven terrain.

Pochade boxes contain a palette and double as handy, small easels. Pochade boxes come in many different sizes (10" × 12" / 25.5 cm × 30.5 cm is ideal for travel) and, like paint boxes, can have a bracket affixed underneath to attach to a camera tripod.

Another practical easel alternative is the Easel Pal; a box that folds out to give the artist additional working space, and solves the problem of carrying wet paint. It can be used with disposable paper palettes (Amigo Arts makes good ones in two sizes).

What's in an Easel?

Your easel can hold most of your painting materials, if you plan it right. You can lay paints out the night before on the palette inside the easel, and the right easel will also hold: brushes, extra paint tubes, paint cloths, solvent containers, media, solvents or solvent substitutes, palette knives, a small can (for example, a tuna can) for daubing drippy brushes, folded pieces of paper towel (Bounty™ seems to be the artist's choice), and painting surfaces.

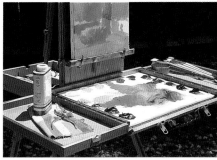

The Easel Pal, designed by an artist for painters on the go.

Packing a Car

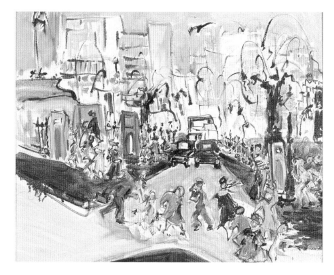

Beacon and Charles
Street Corner,
Lynn Leon Loscutoff

Car packing is an art form in itself. Built-in shelves are a good storage solution. If you have a van, remove the seats so that you can paint from inside in cold or rainy weather. A hanging shoe bag can hold supplies. You can stack wet paintings between plastic stacking trays: Buy them from an art supply store or bread delivery company. I also have a large cardboard box made with wooden grooves glued on both sides, top and bottom. It can hold six 20" × 24" (51 cm × 61 cm) canvases, wet or dry, and a French easel. I can leave it in my car for transporting wet paintings, ship it to a destination, or check it on a plane.

Even when I'm traveling, I like to work big—on canvas sizes 20" × 24" (50 cm × 61.5 cm) or 30" × 36" (76.5 cm × 91.5 cm), or even larger if I go by car or van. So I take a French easel and combine it with an Easel Pal as often as is practical. Paints can be set up in advance on a paper or opaque white plexiglas palette, which can then be fitted into the box's center slot. The box can be closed after painting without disturbing any remaining paint.

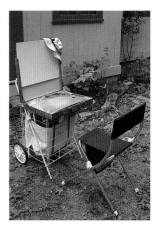

I keep a grocery cart in my car, lined with plastic or a large canvas bag. I load it with a folding chair and a French easel filled with paints and brushes, strap on a stretched canvas, and drive away.

A paint box on a cart can work as well as an easel. Since I am tall, I was happy when I found this adjustable-height chair, which has the additional advantage of a backrest. It is available from Cheap Joe's Art Stuff. I can paint for longer periods of time now, while sitting down in comfort. Especially when I'm recovering from jet lag, a good chair is a good friend.

Packing for Air Travel

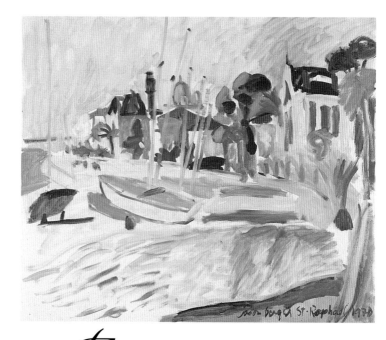

Saint Raphael, *on the French Riviera, Jason Berger*

*F*or air travel, take bag # 3 packed with a French or Russian easel, which in turn contains brushes, paints, alternative (non-turpentine) solvents, and other essential supplies on the checklist. Put these and bag #1 into a zippered canvas bag with a shoulder strap, then attach it to a luggage cart with bungee cords and take the whole thing on the plane with you. Sometimes the airline won't allow the luggage cart to be carried on, in which case you should take essential painting supplies with you and check the rest. The bag 1, 2, and 3 system makes it easy to quickly choose what you need.

I carry a camera and film in a lead bag in my backpack or purse. I also recommend cutting pieces of canvas to size and gessoing them a day or so before you leave. Lay these pieces flat in your suitcase, and bring a piece of foam core—cut the same size as the canvas—to protect finished work. Bring a stapler and a roll of wax paper rolled in with your clothes—the stapler for attaching canvases, and the wax paper for protecting paintings. If you want to take "oil sketching" walks when you arrive, a waterproof bag is another essential.

If there's room, I sometimes bring along an oil pad sketchbook (Canva-Paper from Canson) and a folding stool. Art Pac makes the Rest Everywhere Triangle Chair, a great three-pound version that fits in a suitcase. Whether you have extra room or not, always bring extra bungee cords.

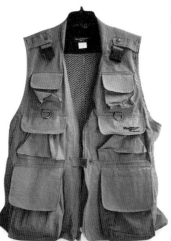

A photographer's vest is great for traveling. It has 18 pockets, inside and out, and can hold your wallet, passport, sketchbook, camera, extra film, and a juicy novel.

Flying Fits

- Measurements for carry-on luggage: standard overhead storage space is 24" long by 16" wide by 10" high. Under-the-seat storage is 21" long by 16" wide by 10" high.

- Outside the United States, check whether the weight limit includes carry-on bags. I do not speak Italian, and what a wonderful row I created at an Italian airport with my French easel and 24 boxed paintings! I was charged many lira, though I had not been charged when leaving the U.S.

- **Traveler's alert:** Turpentine should not be taken on a plane. Under certain circumstances, it can be combustible. To purchase it upon arrival, learn to say it in the language of the country you will visit. (It is often referred to as *white spirits*.) Or buy a nontoxic, non-combustible substitute here at home (see Resources). Mediums should not be a problem to transport. Be sure to leave them in marked containers.

Oil Painter's Checklist

✔ Bag # 1, Bag # 2, Bag # 3

✔ brushes: at least twelve

✔ easel

✔ paints: conventional tubes, Alkyds, oil bars, Max; according to your needs

✔ surfaces: canvas, paper, untempered masonite, gessoed masonite, canvas board, canvas paper, canvas applied to 1/8" Luan plywood, or multimedia art board

✔ solvents: turpentine, turpentine substitute, mineral spirits, medium, linseed oil, gels, or Cobalt fast-drier

✔ brush swiller, or any container to wipe brushes and dispose of used turpentine

✔ photocopies of front page of your passport, make several and put them in different pieces of luggage, in case you lose original

✔ folding waterproof bag

✔ spray fixative, if you use it

✔ charcoal pencils

✔ masking tape

✔ wax paper for covering messy paintings or to use as palette paper

✔ plastic bags for soiled paint papers and for carrying tubes

✔ metal art clips, for holding plastic bags or paper, to act as spacers when storing wet paintings, or to hold up britches if you lose your buttons. I like to keep about 6 handy.

✔ double-dipper, metal, clip-on containers for medium or solvent

✔ disposable paper palette pad

✔ plastic traveling palette with cover, such as the Lock Box palette

✔ umbrella to shade you or your painting, clip-on folding umbrella available from The Civilized Traveler

✔ Army utility knife—with pliers and scissors, which really come in handy on a long trip, especially for opening those dried-on paint-tube caps (See Resources)

✔ bug repellent

✔ paper towels, which are usually safer than a paint rag. Tear off and fold, rather than packing entire roll.

✔ two-way flashlight that shines ahead and down at same time. Great for night painting.

✔ first-aid kit, or at least a few Band-aids

✔ hat (Tilly makes a good foldable, crushable, all-purpose hat that ties under the chin)

✔ long-sleeved cotton shirt with collar (back-of-the-neck sunburn can be brutal)

✔ UV-rated sunglasses, and a sunglass holder to wear around neck

✔ apron (light, waterproof, and preferably with pockets)

✔ socks, to wear with sandals in buggy grasses, or just for cold feet

✔ fingerless gloves, great for keeping your hands warm, but free enough to hold brushes

✔ rubber gloves, or a product like Clearshield, which forms an invisible coating to protect your hands

✔ luggage cart

✔ bungee cords

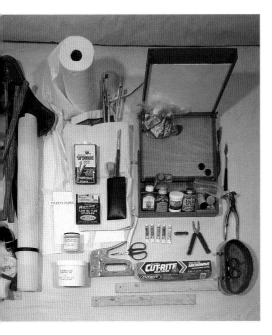

Photo: Tom Markham

ON THE ROAD

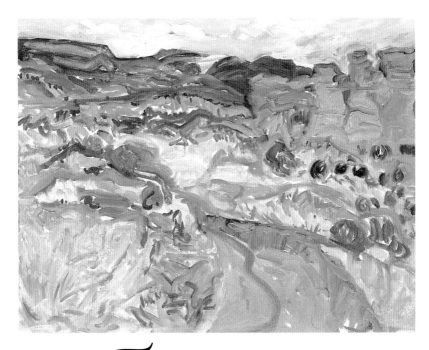

Southwest Mood,
Lynn Leon Loscutoff

*T*wo experiences inspired me to buy a mobile studio. Many years ago, when I traveled through the Southwestern United States for the first time, I staked my claim: I promised myself that I would return one day with my oil paints. I would drive the loop through Monument Valley, Utah, New Mexico, Arizona, and southern Colorado. I would stand where Georgia O'Keeffe stood and make those purple sunsets and golden sunrises mine on canvas.

Then, in Gloucester, Massachusetts, I met artist John Nesta early one morning, painting some tall ships from inside the warmth of his mobile-home studio. He had all his materials set up, and you could smell the coffee brewing. He was looking through the back window and painting from the mounds of color growing on his palette, using a maul stick to get the masts straight. He was as "right there" as any *plein air* artist I have ever seen. From that moment on, I searched for just the right old mobile home with a large wraparound window in the rear. It had to be old enough to mess up with paint, affordable, maneuverable enough for cities or landscapes, and small enough to hide until my husband got used to the idea. I found it finally, and my wish came true: Now I drive and paint my way through the mountains and valleys of the Southwest.

I use my mobile studio whenever possible. I have plastered stickers all over the back so that it looks like a really big guy is the driver. (A lady and a poodle might look a little vulnerable—though my dog, Josephine, is a great traveling companion.)

A Driving Force

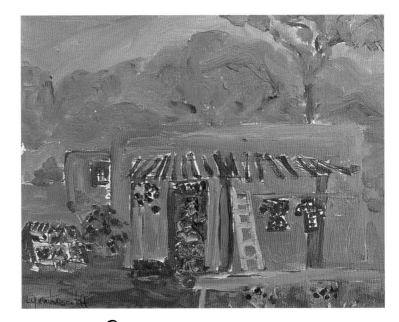

Santa Fe Canyon Road,
*Lynn Leon Loscutoff
Sketch and finished
painting.*

When I paint on the road, whether I am walking or driving, I usually work directly on the canvas. In my car or mobile studio, I like to leave a set-up of materials for use anytime. When traveling by car, I always bring bag #2, and if by chance I see something that I have to stop and paint, I do. If I only have time to sketch, it goes without saying that I also have bag #1 with me. When I am on a full-fledged painting trip, I bring stacks of canvas, all three bags, and, of course, my French easel.

Walking down Canyon Road in Santa Fe, I did this quick little painting by drawing on a canvas with permanent ink. Then I simply painted directly onto the 8" × 10" (20 cm × 25.5 cm) canvas board I had been drawing on. I love making quick little oil sketches when I'm out walking, and I keep a small pochade box, outfitted with primary colors, white paint, mineral spirits, a couple of brushes, and a few sheets of folded paper towel, handy in a backpack just for this purpose.

Study, Santa Fe Adobe

Even if you are working quickly and outdoors, check at various stages of painting to make sure your composition is balanced. In the studio, it helps to pop the image into a frame, but this is not always practical when you work outside. Keep in your mind the goal of creating a "window" in the landscape—and don't sacrifice energy for perfect detail in a work.

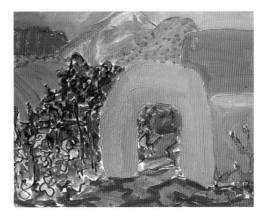

You can make trips last even longer by sketching, taking reference photos, and making notes whenever you have the time. Back in the studio, you then will be able to do variations on the themes you've painted and extend your creative process.

Sante Fe Adobe,
Lynn Leon Loscutoff

During the same trip, I happened to see a remarkable configuration of rocks. The abstract patterns of the formation were so strong and vivid, I had to stop to paint them. I had toned a piece of masonite in advance—a good

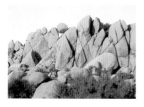

A quick outline of the rocks on the prepared surface, drawn with a brush and just a little solvent.

Quickly mass in the local color, try to keep the shapes and contours.

thing to do if you are spending some time in one a particular area. If you know what colors to expect, as I did in the desert, choose a complementary color and use it to tone your painting surface. Since I knew I would be working with hues of gold, rust, yellow ochre, and Indian red—I toned a value of the complement on a piece of masonite.

Moving quickly often requires leaving out details. Sometimes a camera can help save the important ones better than memory can. Therefore, my policy is take as much photographic equipment as I can conveniently carry. The photograph I had taken of the wonderful desert rocks was invaluable in finishing the painting. I also recommend using a video camera for capturing sounds as well as sights and re-creating local atmosphere wherever you happen to be. I record spoken notes and comments on the audio portion of my videotape.

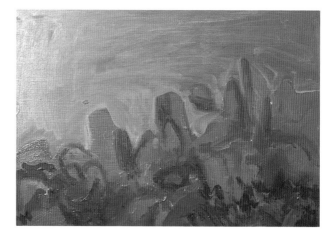

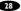

As soon as possible, develop slides from a trip and store them in plastic slide guards in a binder. Indicate the date and place on the tab of a file sheet insert. Polaroid photographs are even easier to use; they can go right into a sketchbook, along with notes, cards, clippings, other memorabilia, and comments. Be sure to mark the trip and dates on the outside, so that you can begin to build a sketchbook library.

To save space on long trips, I take the film out of the boxes and wrap the plastic containers with masking tape indicating film speed and number of exposures. I remove the tape after a roll is used so I don't confuse it with unused film. Finally, a wide-angle disposable camera is wonderfully handy for vast panoramic shots of landscape.

I wanted to keep a dark and light pattern here. I always work to balance the surface. I keep some of the undertone by making certain areas more transparent, and then I build up color to show form on others.

I did continue on to create a more solid feeling—is it finished? I'll look at it again later.

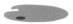

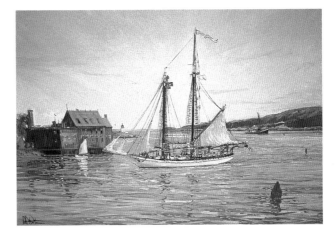

The Coronet, *John Nesta Painted from Gloucester Harbor Beach.*

John Nesta is always in love with his next painting. He keeps his mobile home, which houses his studio, parked outside the door. When he leaves to go painting in the morning, his studio goes with him. He leaves his paints and supplies set up on a permanent basis, so that even when he is not on the road, his studio stays mobile.

A Gloucester native and an artist since the age of five, Nesta always knew that painting in oils was to be his life's love. For more than forty years, he has traveled and painted throughout the United States. He maintains a home base above his gallery in historic Rocky Neck, the oldest art colony in America, outside the seacoast town of Gloucester. In any kind of weather, he can be found painting along the rugged New England shores. And like a turtle with his shell, he takes his studio wherever he goes.

On the day I caught up with him, Nesta had set up to paint some of the sailing boats that come into Gloucester harbor. He works quickly. Often, ungessoed masonite is his surface of choice. He suggests toning the canvas first with a dark color, and then working back to light. He also advises that you try to paint every day, no matter where you are. He not only takes his own advice, he paints so often that it seems he doesn't even have to stop and wash his brushes. They, like John Nesta, are in constant motion.

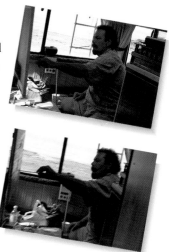

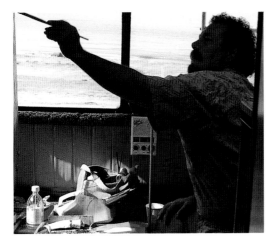

Two Painters Who Walk to Paint

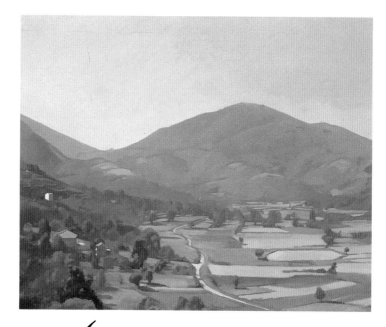

Campodimele,
Diana Horowitz

*D*iana Horowitz feels that it takes time to know a place well enough to paint it. The best way for a traveling painter to get to know a location—whether you are there for a short visit or a long stay—is to take long walks and bicycle rides to discover painting spots.

An accomplished painter who has traveled the world, from California to New York and from Italy to Poland, Horowitz has learned that her response to an environment takes time and that the spirit of her work improves the longer she is in a place. Her specialty is small works on canvas, masonite, and paper. Once she finds a spot, she

often takes fifteen days—working three to four hours a day—to complete a painting. She may continue to work for days on a painting that, to an onlooker, appears already finished: bringing some aspects out and pushing others down. Seeing the work at the beginning and then at the end of the day, you might think she had done nothing. But in reality, she has made many changes whose individual effects improve the whole. It takes time for the entire composition to become simplified. Her goal is to record, as closely as possible, her very first impression of the site.

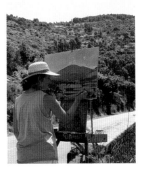

On location in Campodimele, Italy, Diana Horowitz's attention to detail is evident. Italy is a favorite painting destination, though on all trips she is prolific. On one three-week journey to Florence, she produced seventeen paintings: thirteen studies and four full-length works.

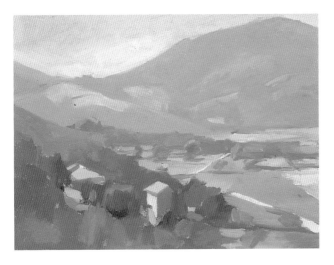

Study, Campodimele, *Diana Horowitz*

Study for McIndoe Falls,
Vermont

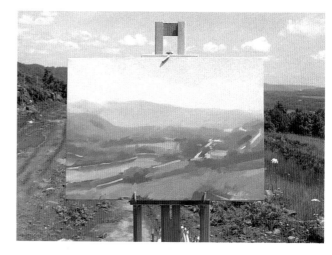

*The umbrella stroller/lug-
gage cart à la Horowitz*

A child's "umbrella" stroller has become Horowitz's mainstay for carrying her favorite painting gear, it has essentially replaced a luggage cart. She includes a half-size French easel in a bag with a small jar of turpentine, paper towels, and various sizes of masonite: small ones for short trips, larger pieces for longer trips. She still uses a backpack for very rugged terrain.

Horowitz often does three studies a day. Each takes two or three hours. The study for *McIndoe Falls* (14" × 20" / 35 cm × 51 cm) was done at midday. She does no preliminary drawings, but many of these studies. Then she examines them and decides which ones she will finish.

To begin, Horowitz works on the abstract, underlying geometric shapes, composition, and dynamic symmetry—building from general to particular. She does not tone the canvas before she starts. If you adopt a mixture of three parts turpentine to one part linseed oil as a medium, you can mimic the dry, crisp look and the clear tones that are her signature. The final product shows classical serenity of form: The impression of strength in the foreground, placement of man-made structures in the middle ground, and the open space in the background impart depth, while color gives weight.

Horowitz shows genius in depicting the characteristic greens of the Vermont landscape. Combining oxide of chromium green, blue-black, and cadmium lemon (all from Winsor & Newton), she has come up with a winning formula.

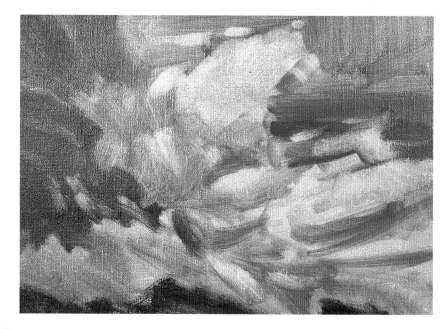

This study began on an unstained panel. Painting in "reverse", which makes colors vibrate, Stone uses the complement of the final color. For instance, if something will be red, he begins with green. It is important to keep the under-painting warm, and to establish a strong dark.

Don Stone, NA, AWS, walks to leave his own foot-prints in the paths where so many master painters have walked and painted, on Monhegan Island in Maine. He shoulders the strap of one of his collection of pochade boxes and has everything he needs to paint. Whether you are walking in Paris or on Maine's most paintable island, Stone has two pieces of advice: Keep your gear light and compact, and don't run around looking for the perfect subject matter. After all, subject matter is nothing more than a good excuse to paint.

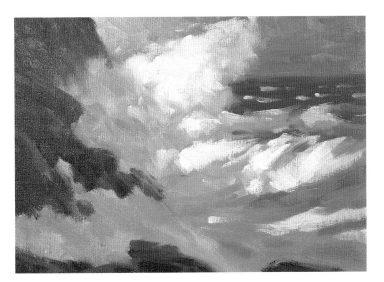

When you are in a new area, try not to paint the obvious, says Stone. Instead, try to get a few good field studies with concept, composition, value, and color notes to take back home. Go with an open mind, searching for the all-important "light on the subject."

Stone's painting equipment is very simple: a small 6 " × 9 " (15 cm × 22.5 cm), 8 " × 10 " (20 cm × 25.5 cm), or 9 " × 12 " (22.5 cm × 30.5 cm) pochade box. These compact boxes are made of solid cherry, and hold brushes—cut to size—and tubes of paint. They are fitted with a bracket for attaching a tripod, and they pack easily in a suitcase—with room left over for clothes.

Keep the value structure close to that of the final painting. Cover the reverse colors with the final colors. To help keep values separated, let some underpainting continue to show through.

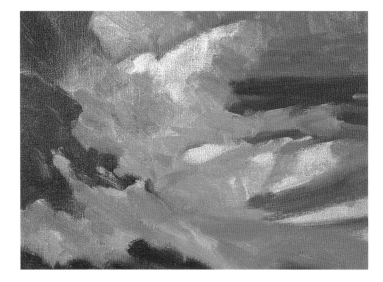

For the sunlit foam, Stone partially mixes white with cadmium yellow and cadmium red. The sunlight shows a lot of pigment, on Stone's theory that sunlight in painting consists of color, detail, and texture while the shadows establish solidity but are transparent.

When Stone travels, he carefully matches his palette to the one he uses in the studio: cadmium lemon yellow, cadmium yellow, yellow ochre, cadmium orange, cadmium red rose, rose madder genuine, ultramarine blue, cobalt blue, Winsor or thalo blue, and Permalba white. He sizes canvas panels to fit the pochade box, then coats them with gesso. He buys everything else he needs when he arrives. It takes a lot of painting on location before you find yourself able to work from photos. According to Stone, the best field studies capture the excitement of the location.

Once he has decided what to paint, Stone makes several thumbnail studies. Concentrate first on concept, he advises, then on composition for the variety of shapes, and

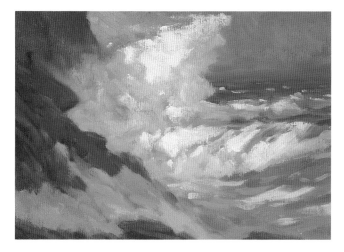

finally, on the separation of the all-important values. Focus on the shapes in nature; don't artificially impose your own. Study the way a certain shape will occupy an area in relation to its surrounding shapes. As for values, keep to a well-defined two or three, and no more than four. The reason for this is the fewer values, the stronger the finished work. Stone establishes the value by observing the angle of the object in space.

The goal for applying color is also simplicity of theme: warm against cool, light against dark, heavy impasto in the sunlit areas, transparency in the warm darks. Also, when applying the pigment, follow Stone's lead and try to "sculpt" with your brush: Let your strokes follow the undulation of the earth, the crest of a wave, or the wispy outline of a wind-blown cloud. Stop looking at trees, rocks, sea, or sky—and start to look at shapes.

During the last stages, concentrate on refinement and strive for better color and pigment application. At the same time, try not to overwork the painting and lose its spontaneity.

Have Pochade Box, Will Travel

Charles Sovek and his pochade box.

Charles Sovek is an inspired and dedicated teacher who has conducted painting workshops abroad, and from Maine to California. His paintings show him to be an expressive master. He works to simplify complex subjects, but light and source values are key to his technique. He says, "Tune yourself in to what you're painting, catch the light, but don't forget the unique character of what it is shining on." He teaches his students to strive for a sense of place in their paintings. Adept at creating a successful marriage between objective observation and personal response, Sovek is also expert at packing up oil paints for travel. His art-packing flight plan is invaluable. Here, then, is the "Sovek Solution."

The custom-made box secures with two sets of latches.

A well-traveled pochade box plays a starring role in Sovek's success: It has accompanied him all over the world, and helped him to capture the sights wherever they may be. The box, and Sovek, have braved rocky terrain, sea spray, and lots of weather, all in the name of making a good oil painting. Instead of the backpack worn by most painters, Sovek carries his pochade box in a canvas bag slung over his shoulder.

Designed to hold twenty-four small canvases, some clipped together at the top with art clips, the pochade box is fitted with individual slots so that more canvases can be set on top. Notice the ridges that keep paintings from marring each other. Smaller boxes stack in the frame, and hold brushes, solvents, tubes of paint, mediums, and a palette scraper (to scrape excess paint into a little can). Pairs of gloves and socks work as wedges to keep things from moving around. This neat kit fits handily into the overhead compartment on an airplane.

Once you have mastered Sovek's creative packing technique, take some time to study his equally wonderful color principles. For Sovek, there are only three ways to approach color. The first is the purest: Here, the painter concerns himself with effects that can be achieved with color. The second, more classical, approach is to regard color as the handmaiden to tone, and to let the values dictate the form and mood of the picture. The third and most popular approach is a combination of the first two. By sensibly merging both color and tonal techniques, the artist is able not only to paint a picture that is colorfully assertive, but to richly model a pattern with a full range of values.

Small boxes organize the pochade box interior. Canvas boards, made of 1/8" Luan plywood covered with canvas, are good, lightweight painting surfaces. To make them, wet both sides of the wood with water (to prevent buckling) and paint white glue on the "canvas" side. Attach the canvas and smooth out wrinkles with a plastic card.

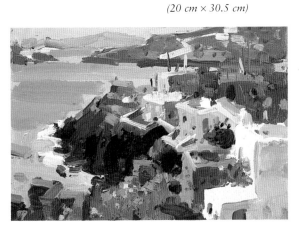

View of Hermoúpolis
8" × 12"
(20 cm × 30.5 cm)

The Sovek pochade box,
on location in Greece, is
shown mounted on a tripod.

A painting of Finickus
Harbor, done with the
famous pochade box.

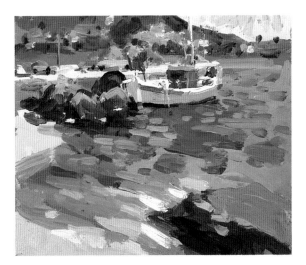

The box, set up on
Finickus Harbor in
Greece.

Mission San Xavier del Bac, Tucson, Arizona 14" × 14" (35.5 cm × 35.5 cm)

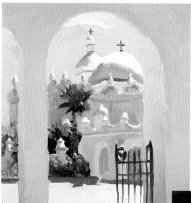

The box, open and ready to go. The paint tubes a stored under the palette when not in use.

The pochade box doing its job at Taos Pueblo, New Mexico.

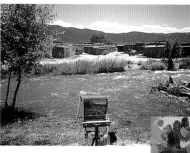

This painting was done on site at a desert pueblo in the unmistakable alla prima style of direct painting. The landscape's expressiveness reveals much about Sovek's technique.

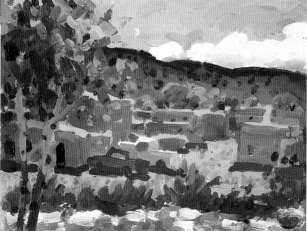

Gulls and Trawlers,
Provincetown 8" x 10"
(20 cm x 25.5 cm) From
the East Coast to the West
and back again.

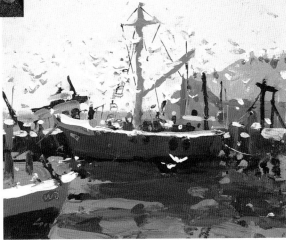

Diptych, Morning Light,
the Grand Canyon 13" x
16" (33 cm x 40.5 cm) and
13" x 16" (33 cm x 40 cm)

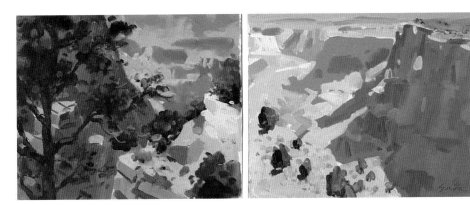

On the Run: Quick-Drying Alkyds

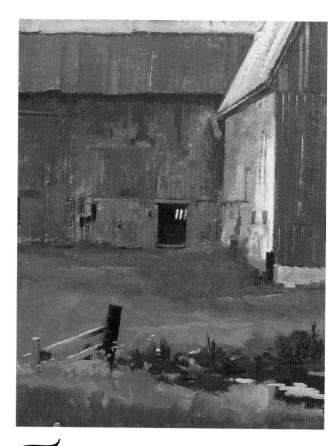

Barn Door,
Hammondsport
Thomas S. Buechner

*T*hey look like oils. They dry faster than oils. They don't yellow or crack and are even more permanent than oils. They have the same buttery consistency as oils. What are they? Alkyds: a luminous paint that behaves much like standard oil paint, but dries far more quickly and maintains better clarity over time.

All photos in this section are by Charles Swain.

Thomas S. Buechner says, "You can't beat them for outdoor paintings. You can go away somewhere and paint for a week and bring home dry paintings."

Alkyds are a fast-drying resin binder that has been mixed with pigments. The resin is a natural material derived from plants. Winsor & Newton makes a complete line of alkyd colors and mediums, sold under the name Griffin Alkyd Colors. The most commonly used alkyd medium, also made by Winsor & Newton, is called Liquin.

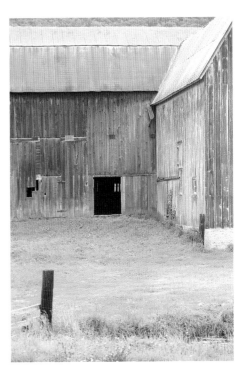

Give a busy painter a challenge, and he finds a solution. Between work obligations, Thomas S. Buechner paints in alkyds. As the former director of the Brooklyn Museum in New York City, and the Corning Museum of Glass in Corning, New York; and as former president of Steuben Glass, Buechner is not used to having a lot of time to wait around for things to dry. The alkyds system offers dry-to-the-touch paintings in twenty-four hours, which Buechner finds invaluable.

Barn in Hammondsport, a small town in New York's Finger Lakes region.

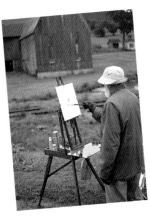

I travel with a half-size Julian easel, loaded as follows:

- **Paint**

 Alkyds *(Winsor & Newton's Griffin):* titanium white, yellow ochre, burnt sienna, ultramarine blue. Oils: titanium white, yellow lemon, orange, alizarin crimson, cerulean blue, Prussian blue, and sap green—all in small tubes.

- **Brushes**

 Best Bristle Brights, numbers Two through Ten, flat sable, number Three, sable

- **Also in the box:**

 a pair of small pliers for tight caps, a three-part maul stick, Phillips-head screwdriver for tightening box joints, two palette cups, plus one adapted to hold a cigar, a palette knife, push pins to hold refuse bag, shock cord to attach palette to box drawer.

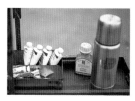

Thomas S. Buechner's paint box

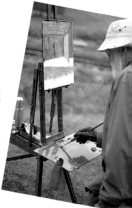

In addition to a fully-packed paint box, Buechner takes along 8" × 10" (20 cm × 25.5 cm) and 11" × 14" (27.5 cm × 35.5 cm) multimedia art boards, plus eighth-inch masonite supports and art clips to attach the board to the masonite. He carries with him a knitted cotton rag, a compact camera, extra film and batteries, a brimmed canvas hat, fingerless gloves, and, of course, a small thermos of coffee and a good cigar—double Corona—to keep the bugs away (among other things).

The surface of multimedia board is very absorbent, so Buechner makes his underpainting and *imprimatur* simultaneously. He plans and paints a value composition first, then blocks in the big shapes and builds up local color. Even though the day was cool, the roof of the barn he paints here was warm. The reflected and absorbed light brought out the golden colors of the rust. There was also not a lot of sunshine; therefore, few shadows are in the painting.

When you work with alkyds, it is easy to work over areas, and to let some of the dark shapes of the values come through. By combining oils, which dry slowly, and alkyds, which dry quickly, in the appropriate proportions, you will be able to handle most variations in climate. However, be careful not to put too much alkyd on your palette if the day is hot. The paint hardens quickly, once it is dry you can't wash it off your brushes or palette. This quick-drying quality also means that you must take care in painting over your value study.

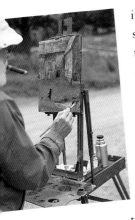

When he had finished painting the barn, Buechner offered some final words of wisdom to the traveling painter: Wear layers of clothes in dark neutral colors that will not reflect on your work; be able to hide your camera; cover yourself with bug repellent; and always edit your paintings— check for detail and consider how much to put in and how much to leave out. Enjoy your trips as much as I have enjoyed mine.

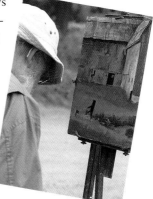

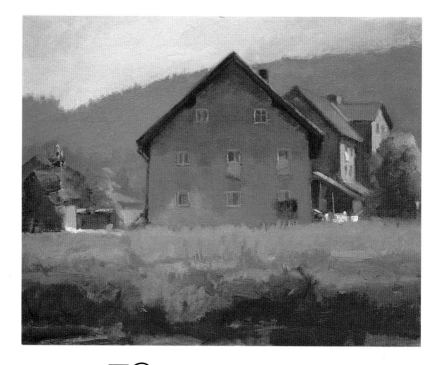

Bavaria,
Thomas S. Buechner

ou have mastered traveling light, sketching and painting on the run, and training your eyes—as well as your other senses—to "look to remember" the sights, the colors, the entire atmosphere and feel of a fascinating location, so that you can set it down in paint. What is the next step? It may well be leaving home to paint "on location." How might changing your location— for any period of time from a month to a year or longer— have the potential to revitalize your art? The painters profiled in this chapter each have asked that question at

least once in their careers, with illuminating results. Returning briefly to the basics: how do your materials change when your location changes? A move may open your work to the new possibilities offered by oil sticks and "water-friendly" paints. And who knows—a change in materials may herald a whole new change in style, or even vision.

As always, planning your time on location is key. If you will be going to a new spot, you may want time to get acclimated. Some artists need time to "read" the subject, or to study the light, the local color, and the atmosphere, or to look for a painting site. If at all possible, I like to arrive a day or so early to reorganize my equipment. I set up a workplace in my accommodations, for finishing and storing work and so that it will be easy to access my materials.

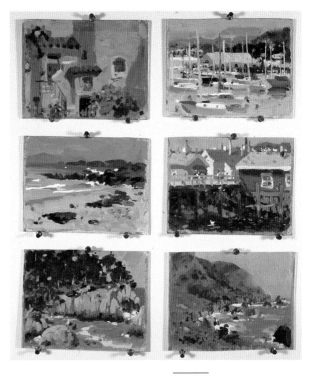

Six scenes of Carmel, California, Charles Sovek 6" × 8" (15 cm × 20 cm)

Oil in a Bar Travels Well

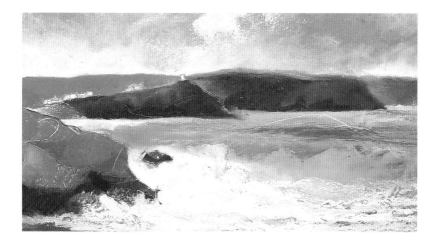

Perranporth,
Simon Marsh
6.5" × 11.75" (16.5 cm ×
29.5 cm)

O il sticks have provided a particularly physical painting experience for painters Simon Marsh and Roger Martin. Simon Marsh paints the coast of England and Wales, while Roger Martin paints his beloved coast of Cape Ann in New England.

Both artists agree on the tactile satisfaction of using oil sticks, or oil bars. Most importantly, both agree that this form of oil painting suits their style. Marsh says, "I very much like the quality of working wet sticks together and sinking through the surface, changing the nature of the drawing or painting. Another great advantage is that oil sticks seem to dry very quickly."

Simon Marsh recently chose a remarkable painting goal: a sixteen month stay exploring and painting pictures of 3300 miles of the English coastline. His sponsor for the trip, the freelance curator Benjamin C. Hargreaves, had promised some exhibitions upon his return. The goal, which Marsh realized beautifully, was to record impressions of the people and views of the seacoast and landscape.

Marsh always has been interested in integrating his painting with other pursuits to yield provocative new forms and insights. For example, he has published much of his work in a book, *Walking at the Edge of the Sea*, accompanied by the poems of Marie Scott. He travels with an abbreviated selection of art supplies, including pens, pencils, brushes, tubes of gouache, printer's inks, oil pastels and sticks, cut-off pieces of vinyl for a palette, and 35 sheets of Saunders 500 gm paper (which needs no prime for oil sticks).

Opposite Porth Dinllaen,
Simon Marsh
6.5" × 11" (16.5 cm ×
27.5 cm

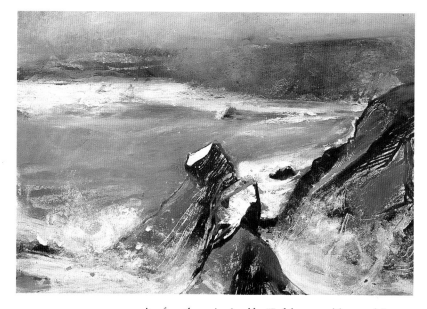

Cliff study—St. David's,
Simon Marsh
8.25" × 12" (21 cm ×
30.5 cm)

As for the trip itself, "I felt very liberated," says Marsh, "my paintings were to be working sketches for prints in the book. I experimented with all of the materials I took on location and found that the oil sticks turned out to be invaluable. I used them in a variety of combinations in all of my paintings."

During his stay, Marsh made more than 600 studies. He mixed gouache, watercolor, ink, and oil sticks, to create, *in situ*, amazing effects. Since oil sticks take five to six hours to dry completely, Marsh recommends putting finished work into plastic sleeves and storing them together in a folder. Paintings won't be damaged, due to the tough-

ness and quality of the Markal oil sticks. You can even break off bits of them, mix them on a paper palette, and apply them with a palette knife, brush, or your fingers. You can also build up a thick surface with oil sticks and take a sharp instrument or the end of a brush and expose under-coating with the point.

Pennine Way (First Snow), *Simon Marsh* *6.75" × 11.75" (16.5 cm × 29.5 cm)*

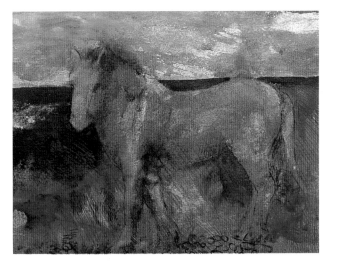

Beach Pony near Mary Porth, *Simon Marsh* *8.25" × 11.75" (21 cm × 29.5 cm)*

Interstices, *Roger Martin*
40" × 50" (102 cm ×
127.5 cm)

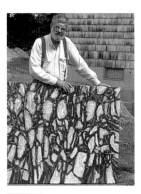

The granite coast of
Rockport imparts to both
landscape and citizens a
characteristic quality of
energy and strength.
The scale of Martin's
paintings reflects the scale
of his feelings for this
light-filled retreat.

Oil sticks were a fortuitous discovery for Roger Martin, an instructor, author, poet, and painter. Already an established painter in standard tube oils, he began using oil sticks after an injury to his right arm. This accidental introduction has led to a wonderfully productive working relationship between artist and materials.

Martin's art work has much to offer the traveling painter seeking inspiration. When you are on location, soak in your surroundings. Notice everything, then capture your impressions in quick oil-stick sketches. If you are painting on the coast, as Martin does, track the changing patterns of the rocks, the shore, and the crashing sea. Pay attention to the swirling circles, sharp edges,

broken edges, soft edges, hard edges, texture or lack of it, and the motion of diving and rising waves. You will find that your paintings become inextricably linked to your feelings about the landscape.

Martin's favorite painting location is the New England coastline. His roots are anchored in the little sea-side town of Rockport, Massachusetts, and his art is defined by his unending fascination with the area's granite ledges and cold Atlantic surf. He finds constant interest and drama in the changing natural panorama. Each morning, he steps out to with his oil bars and works to recreate the gestures of the waves and rocks in abstract images.

Black Rocks,
Roger Martin
36" × 40" (91 cm ×
102 cm)

Tidal Pool, *Roger Martin*
30" × 40" (76.5 cm ×
102 cm)

Mixing Oil and Water

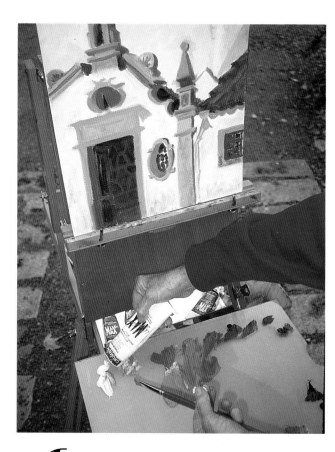

Church, Viana do Castelo,
Portugal, *Ann Fisk*

*A*nn Fisk has organized and led painting trips for more than eight years. She has used Max Oil Color paints (which clean up with water, don't require solvents, and mix with standard tube oil paints) on travels in Greece, France, Ireland, Yugoslavia, Italy, England, Nevis, Santa Fe, and, most recently, Portugal.

For Fisk, one of the great benefits of leaving home to paint on location is the close-knit group of traveling companions she has come to know. Another is the pleasure of painting with oil paints that clean up with soap and water.

Fisk's approach to packing is simple: a small plastic bottle for water; Grumbacher Oil Painting Medium #3, to aid the flow of color, increase gloss, and speed drying time; and a small squirt-container filled with detergent (such as Tide) for cleaning her palette. Since Max paints can be used with regular oils—one-third Max to two-thirds oil paint—and still clean up with water, Fisk does not need to carry solvents.

Fisk advises becoming a "sneaky sketcher" when you travel. Busy markets, streets and alleys, ports and railroads can all belong to you. Make sketches and color notes to capture the local atmosphere wherever you go.

Painting in Company

Have you considered joining a painting-traveling workshop? The intensity of focus they offer can be perfect if you have been away from your paints for a while. It is wonderful to arrive in a beautiful location with your gear, be warmly welcomed, have an instructor to guide you and, in some cases, even a chef to feed you. *American Artist* magazine lists many such workshops, as does *Artist Smart Traveler.*

One organization, the *Hewitt Painting Workshops*, recently celebrated its fortieth year of taking groups all over the world. Another, the *Merle Donovan Workshops* in Port Clyde, Maine, offers the opportunity to paint with famous guest instructors or take the ferry boat for the day to Monhegan Island. Finally, artists from all over attend workshops such as the one led by Charles Sovek at the Rockgarden Inn in Sebasco, Maine.

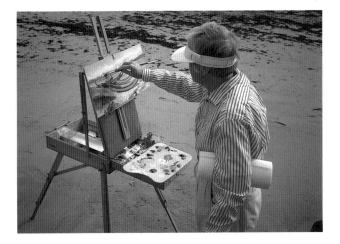

Ann Fisk with French easel and Max oils.

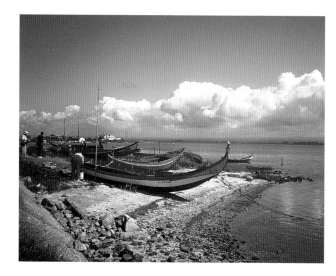

*An inspiring scene on
location in Algarve,
Portugal.*

To make color choices easier, she uses a relatively limited (12 or fewer colors, depending on climate) palette: thio violet, thalo blue, cadmium yellow, cadmium red light, titanium white, and yellow ochre. A plastic cup clipped to her easel holds a little detergent in water.

All the same painting surfaces that are used for conventional oil paint can be used with Max; however, unprimed canvas should not be used. Fisk's surface of choice is Multimedia Artboard. Caution: it won't bend without breaking. Watercolor paper, with gesso or without, in 300-lb. rough also works well. Use a plexiglas palette in a plastic keeper box with this paint, since it will stay moist for at least four days.

Max can be thinned with conventional oil-painting mediums, or gel and alkyd paints. You also can mix a glaze with two parts Max and one part linseed oil. A few drops of alkyd painting medium can be used as a drier prior to adding linseed oil.

"Painting trips are busy enough," says the artist, "it is a blessing not to have to worry about anything else besides water." Even if you paint with traditional oils in the studio, you may find that you agree with Ann Fisk when you paint on location.

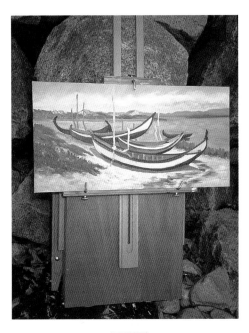

A French easel lets Fisk carry finished paintings and supplies from location to hotel and back again.

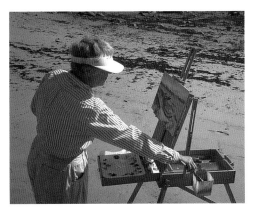

Brushes made for acrylics and synthetic-bristle brushes are good for painting with Max oils. Avoid hog-bristle brushes, since their texture is too hard for this medium.

Change Your Location,
Change Your Life

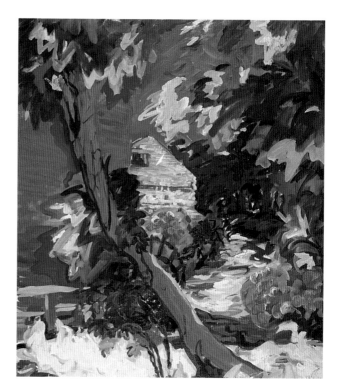

My painting of a mill pond in the village.

*A*t one time in my career, I served as the executive director of the Copley Art Society of Boston. I was so busy all the time, that the thought of taking an extended painting trip was not even a daydream. Then Jason Berger, a wonderful painter, instructor, and one of my mentors, casually remarked to me that he was taking a group of students to Normandy for the summer.

Did I know anyone who would like to go? The trip would entail traveling to a little village on the coast, Veules les Roses, and staying in a villa for the summer while painting the town and surrounding landscape.

Well, what would you have said? Once assured that I would not have to be the housemother and that I could have my own room, I went ahead and changed my life. I packed some rolled canvas, stretcher bars (two sets of 20" and 24" bars that could form square or rectangular shapes), pliers, a staple gun, lots of paint, and my French dictionary. Since the arrangements for the group had been made, my only tasks were to arrange the summer schedule for the Copley Society, convince my husband I would keep in touch, and arrive in France a little late.

The villa stood across the street from a watercress farm. It was lovely, and there I spent one of the most wonderful, exhausting, productive summers I ever have experienced. I was so glad I had packed my luggage cart with me. I would walk through the village with my gear in tow. Fishermen on the harbor offered me their storage room to house my art supplies in case of sudden rain. One day, I lost a tube of yellow paint near the spot I was painting, and a lady from the village came all the way across town to our now famous "villa les Americains" to seek me out and return it.

The front entrance of the villa in Veules les Roses.

An unusual place to store painting supplies.

I loved this beach and the people on it. It was like home to me—perhaps because I spent so many afternoons sleeping there in the sun.

We would paint, take our canvases off the stretchers, and hang them on a clothesline to dry. We spent the rest of the time critiquing each other's work and taking the train to the museums in Paris. Sometimes, I had to catch up on my sleep on the beach in the afternoon. The evenings in our little villa would rock with jazz, conversation, and wine and cheese until very late.

We had an exhibition, and many of the local people bought our work. Pretty heady stuff—to be an American making French Post-Impressionist-style paintings and have the French buying them!

At one point I was commissioned to paint the garden of a charming lady executive of *Printemps* depart-

The Beach at Veules les Roses,
Lynn Leon Loscutoff
36" × 48" (91.5 cm × 122 cm)

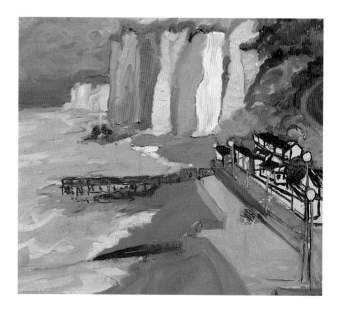

Rooftops, Veules les Roses, *Lynn Leon Loscutoff* 36" × 30" (91.5 cm × 76.5 cm)

ment store. She stayed in Paris during the week and gave me the key to her house so that I could paint her garden while she was away. We became good friends and still correspond. I still remember Claire's garden with great fondness.

The lesson I learned from Jason Berger was: If you want to paint, just do it. If painting is like breathing for you, you must do it and make others understand your need. If you are worried about reconciling your work with your obligations to the people in your life, remember that if your work makes you happy, it will make others happy as well.

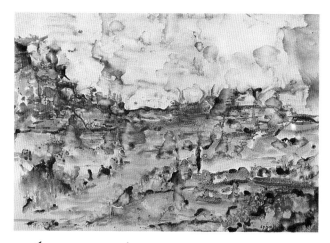

A single monotype of the desert watercolor, painted on a piece of 20" × 30" (51 cm × 76 cm) plexiglas, then printed.

Back home in my studio, it is fun to further develop images from a painting trip. I am especially excited when I can experiment with a brand new material or technique. Playing in the studio brought back to mind the "desert garden" I had painted in New Mexico, and I decided to see how the same scene would look in a monotype and in handmade paper. I don't have a press, so I create monotypes by simply painting my visual memory of a place on a piece of plexiglas. In this case, I used watercolor paint. I wet a piece of Arches 140 lb. watercolor paper, placed the wet paper on the wet paint, and rolled a brayer over the back of the paper. Voila! a watercolor monotype. You can also use the same method with oil or acrylic paint.

Have you ever tried making handmade paper? You can attend a papermaking workshop, or you can make it at home. Recycle used paper by tearing it up and

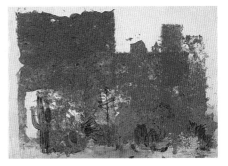

Handmade paper, created working with a reference image.
20" × 24" (51 cm × 61 cm)

mixing it in a blender with water and a little mold-resistant wallpaper paste. Add color with dye or acrylic paint. Squeeze the water from the blended pulp, form it into sheets on a screen (such as an old window screen) and let it dry. I did this with paint colors blended directly into the paper. When the paper dried, I painted over the piece to add even more texture and to make the image more distinct. Another time, I wanted to make a really large piece and I asked a professional papermaker how to get the excess water out of the pulp, so that it would dry faster. I was told to put the paper between two sheets of plywood and run it over with a car.

While painting back at home, I have also recently discovered AquaOil. Whether you use it while traveling, on location, or in your studio, this water soluble, oil-emulsion alkyd paint is revolutionary. I painted a tropical scene in Naples, Florida with AquaOil, and I found that the paint had great intensity. It also required only water—no solvents—for both painting and clean-up. As I painted to emphasize the values or degrees of lights and darks, the thickness and richness of the paint was terrific. The manufacturer, NorArt, also makes Acryl, an acrylic paint that can be used over AquaOil. They have broken the "fat over lean" rule, and so have I. The possibilities of solvent-free (and non-toxic) paints are wonderful. This is going to be such fun.

Painting en plein air in Naples, Florida

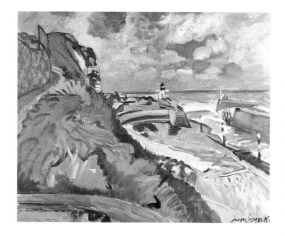

The Cliffs, Saint Valery-en-Caux, *Jason Berger*

There is always something new to see, do, and learn. Although I have already told many painting and traveling stories, here is a final pair to close the book. Two of my mentors, the painters Jason Berger and Alfred C. Chadbourn, have greatly influenced my painting style. Jason Berger paints on location in a very direct and rhythmic style. In his studio, he expands and simplifies images by working a series of paintings from his *plein air* piece. He abstracts all but the underlying structure as the stages of the series progress. Watching him paint has shown me how to extract the essence of a subject. He once said to me that painting landscapes made him feel as if he were on the edge of the earth.

Alfred C. Chadbourn pointed out that traveling to paint does not always mean you have to carry your paint box with you; you can carry the image of the landscape in your head. Once a dedicated painter on location, Chadbourn now travels to a site, makes sketches, does little thumbnail paintings, and takes the information back to his studio to

The Almeida park, Algarve, Portugal, *Jason Berger*

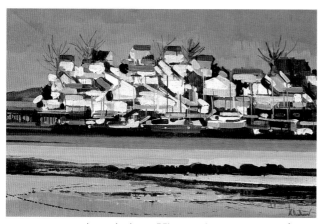

Booth Bay Harbor, Winter, *Alfred C. Chadbourn* *10" × 18" (25.5 cm × 45.5 cm)*

create composite paintings. His creative process combines abstract principles and realistic arrangements, even as his finished products do. Chadbourn uses a method called *halation*, through which a picture can create its own light. The effect is created by placing complementary colors next to each other in line and shadow. The startling result seems to bounce light to the viewer's eye. The Impressionists used "broken" color to get the same "vibrating" effect. The violent contrasts of color can energize a shadow in a high-key painting.

These painters, and many others, have extended the creative process for me, and I hope for you, too. How lucky we are to have open eyes, open hearts, and open minds. Do enjoy every possible creative moment your spirit moves to, and have a happy, healthy trip painting and traveling through life.

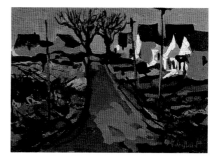

Evening Vinalhaven, Maine, *Alfred C. Chadbourn* *10" × 14" (25 cm × 35 cm)* *Courtesy of Baridoff Gallery & Frost Gully Gallery, Portland, Maine*

 RESOURCES

The companies listed are good sources for many of the art supplies mentioned in this book. Items in italics are products recommended for traveling painters by Lynn Loscutoff. No responsibility is assumed for companies who have changed their addresses or phone numbers, changed their names, changed the names of their products, or neglected to phone their mothers on Mothers' Day.

American Artist Magazine
P.O. Box 2012
Lakewood, NJ 08701
Workshop listing (featured in March issue of each year)

The American Color Company
217 Commercial Street
Portland, ME 04101
207-828-2555
Safer Solve (non-tur-pentine solvent)

Amigo Arts
612 Oreja De Oro
Rio Rancho, NM 87124
505-892-3944
Easel Pal Palette Box

Art Pac
3483 Edison Way
Menlo Park, CA 94025-1813
800-348-2338
Rest Everywhere Triangle Chair

Artist Smart Traveler
84 Langsford Avenue
Gloucester, MA 01930
508-283-0782
Artists' travel resources, AquaOil and Acryl acrylic, Take-It-Easels

Barge Traveling in France
Coordinator: James Wisnowski
1807 North Lincoln Park West
Chicago, IL 60614
Artists' travel resources

Canson-Talens
P.O. Box 220
21 Industrial Drive
South Hadley, MA 01075
413-538-9250
Canva-paper

Charrette
P. O. Box 4010
Woburn, MA 01888-4010
800-367-3729
Aquabee Disposable Palettes in a book of 50 sheets (9" x 12"/23 cm x 31 cm), oil bars, canvas, assorted painting papers

Cheap Joe's Art Stuff
374 Industrial Park
Boone, NC 28607
800-227-2788
Adjustable height chair

Chrislee Darrand
1 Maplewood Avenue
Gloucester, MA 01930
508-281-2821
Markal oil sticks

The Civilized Traveler
54 West 21st Street
Suite 505
New York, NY 10010
212-758-8305
Folding umbrella with clip (to attach to a chair), Double Header flashlight, Tilly hat

Daniel Smith
4150 First Avenue South
P.O. Box 84268
Seattle, WA 98124-5568
800-426-5568 USA
800-426-6740 Canada
*Winsor & Newton
Griffin Alkyd Colors
and Liquin Alkyd
Medium, Winsor &
Newton paints, French
easel, half-size Julian
easel*

Dick Blick
P.O. Box 1267
Galesburg, IL 61402
800-447-8192
*Multimedia Artboard,
Robert Simmons
Brushes, Max Oil Color
Paints, Best Bristle
Brights*

Eddie Bauer
800-426-8020
Vests

Exposure
1 Memory Lane
P. O. Box 3615
Oskas, WI 54903-3615
800-222-4947
*Archival boxes for
storing negatives,
photos, and slides*

**Hewitt Painting
Workshops**
P.O. Box 6980
San Diego, CA
92166-0980
619-222-4405
*Painting and traveling
workshops*

Joan Dunkle
7 Pond Path
North Hampton, NH
03862
603-964-8188
Clearshield

L.L. Bean
Freeport, ME 04033
800-221-4221
*Art bag, waterproof
jacket*

Light Impressions
280 Commerce Drive
Rochester, NY 14623
716-271-8960
FAX 800-828-5539
*Saf-T-Stor Pages,
Photo Archives*

M. Grumbacher Inc.
Cranbury, NJ 08512
800-346-3278
*Brushes, Oil Painting
Medium #3*

**Martin F. Weber
Company**
2727 South Hampton
Road
Philadelphia, PA 19154
215-677-5600
*Turpenoid Natural
(non-turpentine
solvent)*

**Merle Donovan
Workshops**
Route 37
Port Clyde, ME 04855
207-372-8200
Artists' workshops

**New York Central Art
Supply**
62 Third Avenue
New York, NY 10003
800-950-6111
FAX 212-475-2513
*Saunders 500 gm
paper*

NorArt
Harstrup Associates
510A Stover Avenue
Pelham, NY 10803
914-738-7186
*Edvard Munch
AquaOil*

Quiller Gallery
P.O. Box 160
Crede, CO 81130
800-876-5760
*Jack Richeson Artist's
Backpack, Backpack
Safe-t-Lock*

Roberts Hardware
Woodside, CA 94062
415-851-1084
*Hanig & Company
Lifelong Knife with
pliers, screwdriver,
and bottle opener*

Steve Congdon
81 Southern Avenue
Essex, MA 01929
508-768-7904
*Pochade box ordering
information*

Uniform City
800-600-0550
*Apron, smock, poly-
ester or cotton lab
coats (as clothing
shield), cotton cargo
pants, plastic folding
raincoat for protect-
ing your clothes and
your painting*

Utrecht
333 Massachusetts
Avenue
Boston, MA 02115
617-262-4948
800-257-1108
*paints, brushes,
canvas*

Yarka Fostport, Inc.
65 Eastern Avenue
Essex, MA 01929
800-582-ARTS
Russian easel, brushes

JASON BERGER, born in Malden, Massachusetts, now resides in Lisboa, Portugal. He studied at the School of the Museum of Fine Arts in Boston and later became an instructor. He studied in Paris with a scholarship for several years, and has taught at such universities as Mt. Holyoke College, Boston University, State University of New York at Buffalo, and The Art Institute of Boston. He creat- ed a summer school in Normandy, France for the Art Institute of Chicago, and co-founded the Direct Vision art movement. His work is in the collections of museums throughout the world, including: The Museum of Modern Art and the Guggenheim Museum, New York; The Art Institute of Chicago; Musee Rodin, Paris; and the Institute of Contemporary Art, Boston. His awards include the Boston Arts Festival Grand Prize. Berger is represented by the Alon Gallery in Brookline, Massachusetts.

Jason Berger, Rue Candido de Figueiredo, Lisboa, Portugal

 THOMAS S. BUECHNER resides in Corning, New York. He has served as director of both the Brooklyn Museum in New York City and the Corning Museum of Glass in Corning, New York, and as president of Steuben Glass. He has traveled extensively, conducting painting work- shops throughout the United States, Italy, Germany, and the Caribbean. He continues to participate in conferences on glass and to paint, teach, and do portrait commissions.

Thomas S. Buechner, 11 North Road, Corning, New York

ALFRED C. CHADBOURN, N.A., was born in Izmir, Turkey in 1921. He now resides in Yarmouth, Maine. He spent his childhood in France and California and first studied art in Los Angeles. He is a teacher, the author of two art books, and an extensively collected and highly respected artist. He served as a tank sergeant in the Pacific in World War II and resumed art studies in Paris at the Beaux Arts and La Grande Chaumiere. His awards include a Louis Comfort Tiffany Fellowship in 1959, The National Army's Henry Ward Purchase Award in 1964, and the Dines Carlson Award in 1981. His first one-man show, in Paris in 1949, was patronized by Jean Cocteau. His work is collected by corporations and major museums, including the Los Angeles County Museum, the Portland (Maine) Museum, the Museum of Fine Arts in Boston, and the Corcoran Gallery. He is represented by the Frost Gully Gallery in Portland, Maine.

Alfred C. Chadbourn, 4 Church Streeet, Yarmouth, Maine

ANN FISK (B.A., Design, Stanford University) resides in Rockport, Massachusetts. She served as executive director of the Rockport Art Association for eleven years. Born into a family of artists who love to paint and travel, she is naturally adept at leading artist's travel expeditions and has done so for several years. She exhibits her work in the Cape Ann area of Massachusetts.

Ann Fisk, 8 Pasture Road, Rockport, Massachusetts

DIANA HOROWITZ (M.F.A., Brooklyn College, Tyler School of Art; M.F.A., Rome Program, B.F.A., SUNY Purchase) resides in Brooklyn, New York. An instructor of painting and drawing at the Tyler School of Art in Rome, the Art Institute of Chicago, and Brooklyn College, Horowitz has received numerous grants and residencies from such organizations as Millay Colony, Yaddo, and the MacDowell Colony. In 1993, she received a Pollock-Krasner Foundation Grant. Her paintings have been featured in numerous exhibitions on contemporary landscape art and have been exhibited in countless group and one-woman shows. She is currently represented by the Contemporary Realist Gallery in San Francisco and the Sazama Gallery in Chicago.

Diana Horowitz, 464 Henry Street, Brooklyn, New York

SIMON MARSH (B.F.A., Central School of Art and Design) trained at Chelsea School of Art, London, and resides in London. He is also a printmaker and publisher (Standpoint Press). He has had four exhibitions from his coastline trip in England and Wales, at both the Audley Gallery and the Benjamin C. Hargreaves Gallery, London. His work is shown in the public collection of the Victoria and Albert Museum, ICI collection. He has exhibited throughout Europe, and has published several books of drawings and paintings.

Simon Marsh, 129 Grosvenor Avenue, Islington, London, England

ROGER MARTIN was born in Gloucester, Massachusetts, in 1925. He was an honors graduate of the School of the Museum of Fine Arts in Boston and is now an author (Rockport Poet Laureate for Life) and illustrator. He was appointed first professor emeritus at Montserrat College of Art in Beverly, Massachusetts and is a founding faculty member at Montserrat School of Visual Art. His credits include 23 solo exhibits and as many group shows. He is listed in both *Who's Who in American Art* and *Who's Who in the East*. He is represented in numerous public collections in Massachusetts. His art work, writings, and poems have been widely published.

Roger Martin, 15 Penryn Way, Rockport, Massachusetts

JOHN NESTA resides in Gloucester, Massachusetts. He attended the Vesper George School of Art in Boston and has made an in-depth study of the culture of the Southwestern United States. He maintains his own gallery in the Rocky Neck Art Colony. His travels take him throughout the U.S., and his paintings reflect the breadth of his travels.

John Nesta, 37 Rocky Neck Avenue, East Gloucester, Massachusetts

CHARLES SOVEK first studied painting in his hometown of Pittsburgh at the Art Institute of Pittsburgh, and later at the Art Center College of Design in Los Angeles and the Art Students League in New York. He currently resides in Rowayton, Connecticut. He is the author of three art books and a contributing editor of *The Artist's Magazine* and has conducted workshops, given demonstrations, and judged shows across the United States. His numerous prizes and awards include the Martha Rathbone McDowell Award and recognition from the Kent Art Association, the Salmagundi Club, and The Society of Creative Artists of Newtown. He has more than 800 paintings in private and corporate collections throughout the U.S. and Europe.

Charles Sovek, 3 Logan Place, Rowayton, Connecticut

DON STONE, N.A., A.W.S., D.F., is deeply rooted in the American tradition of Realism. He currently resides in Exeter, New Hampshire, and Monhegan Island, Maine. He is a member of the Allied Artists of America, the New England Watercolor Society, Rockport Art Association, and the Guild of Boston Artists. He has exhibited at the Museum of Fine Arts in Boston, the De Cordova Museum, Dartmouth College, Butler Art Institute, and numerous others. He has received more than 65 major awards, including eight gold medals, two of which were presented by the Franklin Mint Gallery of American Art for "Best Watercolor of 1973" and "Best Marine Paintings of 1974." He is also the recipient of two Greenshields Foundation grants.

Don Stone, 7 Hartman Place, Exeter, New Hampshire

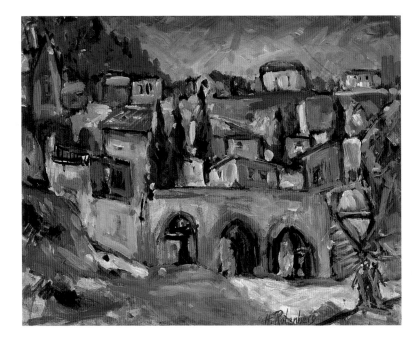

Safed, Israel
Harold Rotenberg
Courtesy of Judi
Rotenberg Gallery, Boston

Harold Rotenberg changed both his location and his life at the age of sixty. The special light and history of Jerusalem touched his artistic spirit and he moved there permanently, acheiving great success with his paintings as a result. At the age of ninety he still paints actively, and continues to touch each work with luminosity by under-painting with gold leaf. "Color gives you form," says Rotenberg, "add a good composition, a happy accident, and you have a painting."

 # NOTES